HOT GUYS and CUTE CHICKS

Audrey Khuner *and* Carolyn Newman

Photography by Eliot Khuner

**Andrews McMeel
Publishing, LLC**

Kansas City • Sydney • London

Andrews McMeel Publishing, LLC
an Andrews McMeel Universal company
1130 Walnut Street, Kansas City, Missouri 64106

www.andrewsmcmeel.com

13 14 15 16 17 SHO 10 9 8 7 6 5 4 3 2 1

ISBN: 978-1-4494-3271-3

Library of Congress Control Number: 2012942643

Also available: *Hot Guys and Baby Animals* (www.hotguysandbabyanimals.com)

Photography by Eliot Khuner

ATTENTION: SCHOOLS AND BUSINESSES

Andrews McMeel books are available at quantity discounts with bulk purchase for educational, business, or sales promotional use. For information, please e-mail the Andrews McMeel Publishing Special Sales Department: specialsales@amuniversal.com

HOT GUYS and CUTE CHICKS

BRANDON and BAILEY

Brandon has 99 problems, but a chick ain't one.

Bailey has only one problem: keeping the other chicks away from Brandon.

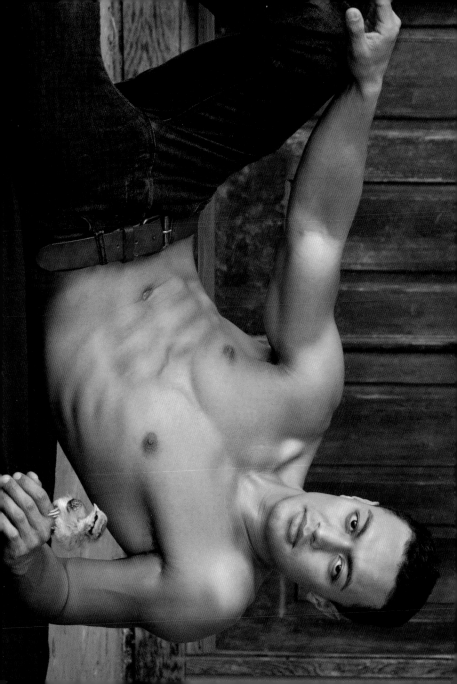

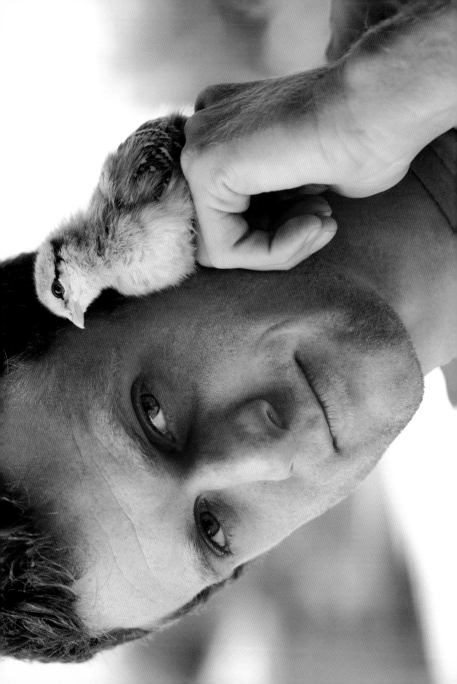

SOLOMON *and* GENERAL BEAKMAN

Solomon likes to live life in the moment.

General Beakman is always one step ahead.

DYLAN *and* SARAH

Dylan still has much to learn.

Sarah ponders deep questions. Which really did come first—the chicken, or the egg?

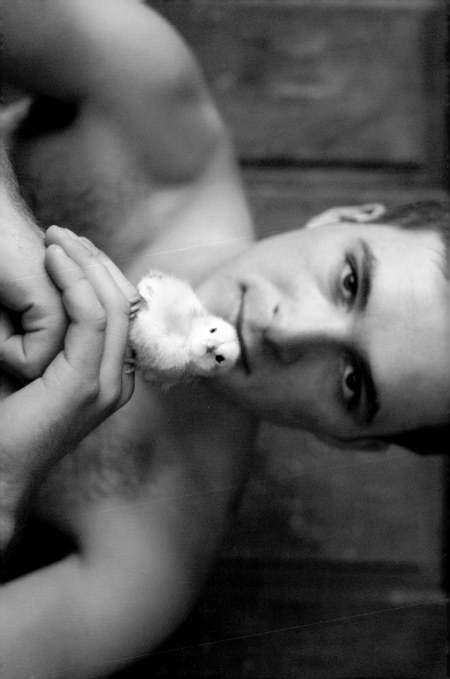

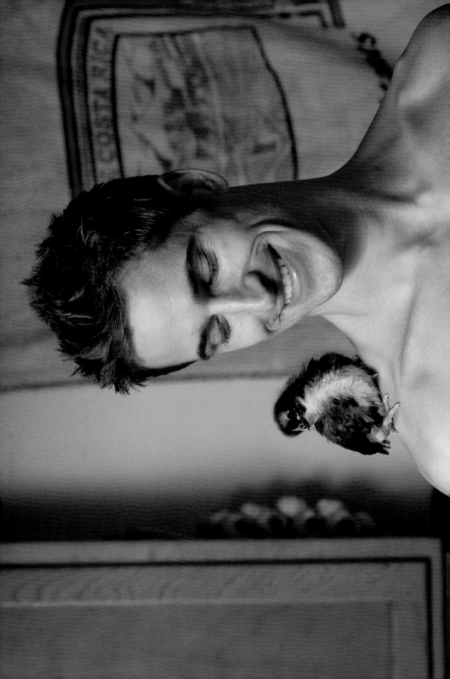

ANDREW *and* ALBERT

Andrew cracks himself up.

Albert does not find Andrew particularly funny.

NATE *and* NANCY

Nate is humble about his hotness.

Nancy thinks she's the cutest chick ever.

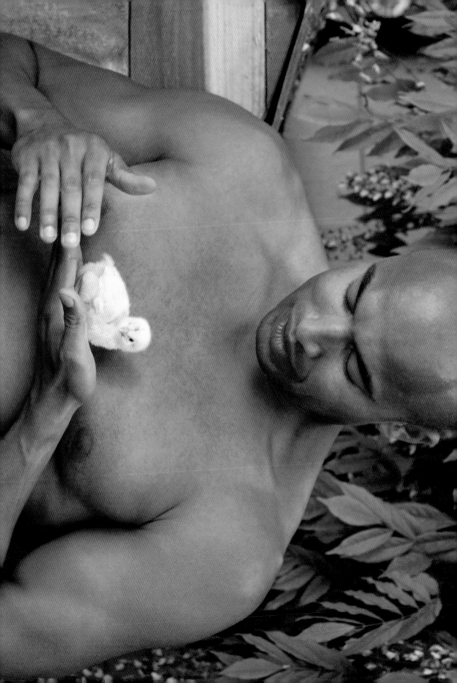

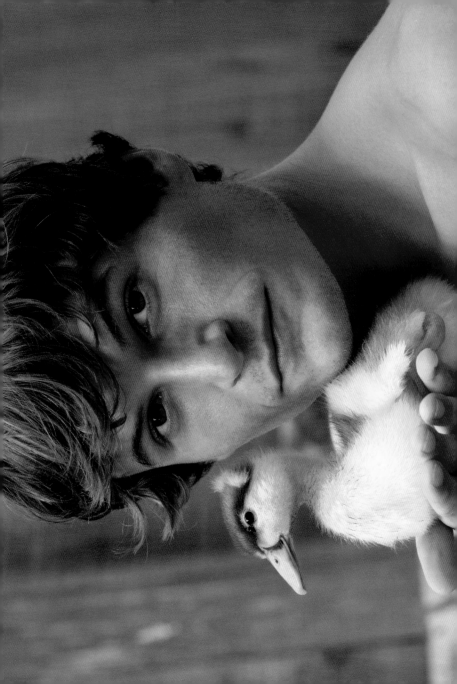

CARL and SPECIAL AGENT QUACKERTON

Carl is an open, trusting guy.

Special Agent Quackerton has his beady little eye on you.

RYAN *and* SHELLY

Ryan is kind of a chick magnet.

Shelly is kind of a Ryan magnet.

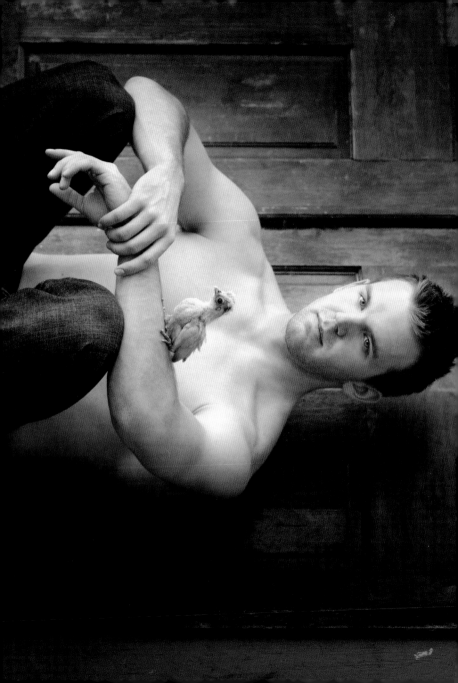

CHAD and BETTY WHITE

Chad likes to throw parties.

Betty White prefers quiet evenings at home.

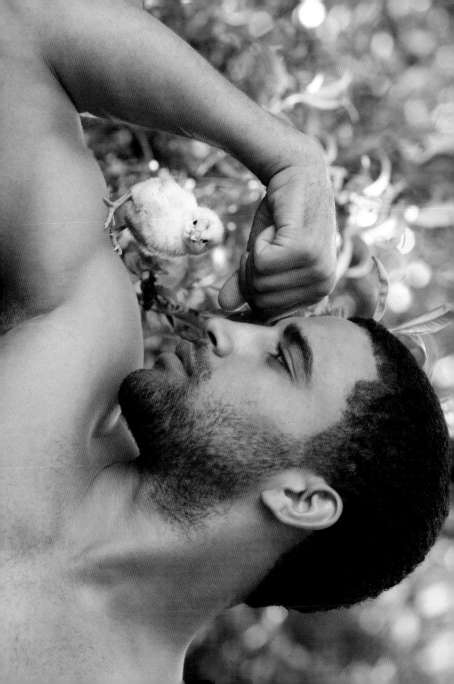

ADAM *and* MR. FEATHER-BOTTOM

Adam is considering what he's looking for in a soul mate.

Mr. Featherbottom is considering how he'd look in plaid.

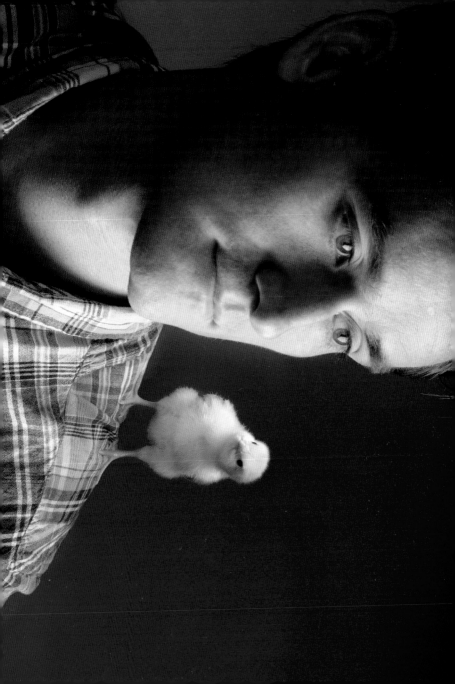

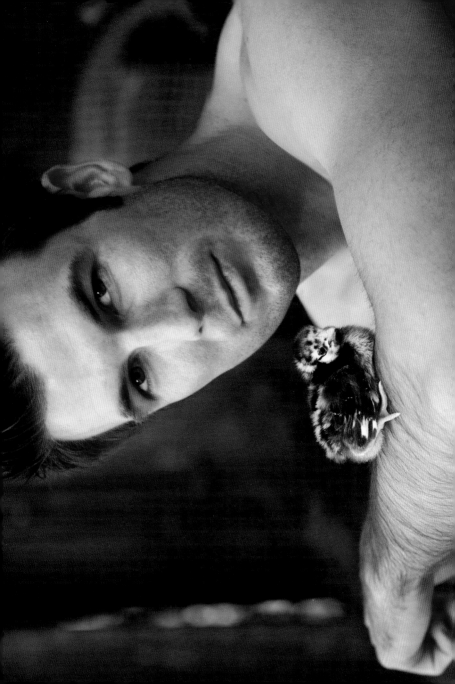

DANIEL *and* RACHEL

Daniel has always been outgoing.

Rachel just broke out of her shell.

FRANK and CHESTER

Frank has big pecs.

Chester is about to peck Frank.

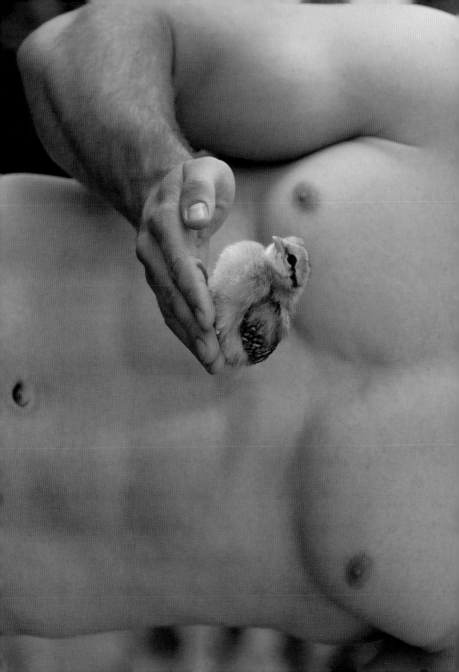

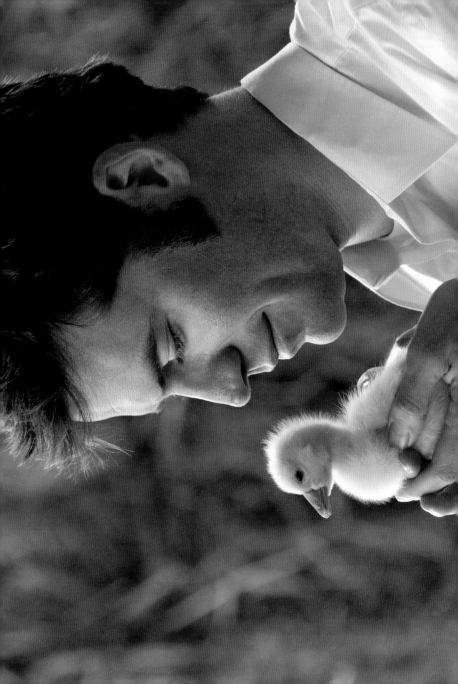

CHRISTOPHER and RYAN

Christopher will seduce you with his mandolin.

Ryan will seduce you with his fuzzy cuteness.

BRANDON, LUNA and LOIS

Brandon is great with kids.

Lois is great with guys.

Luna is just great.

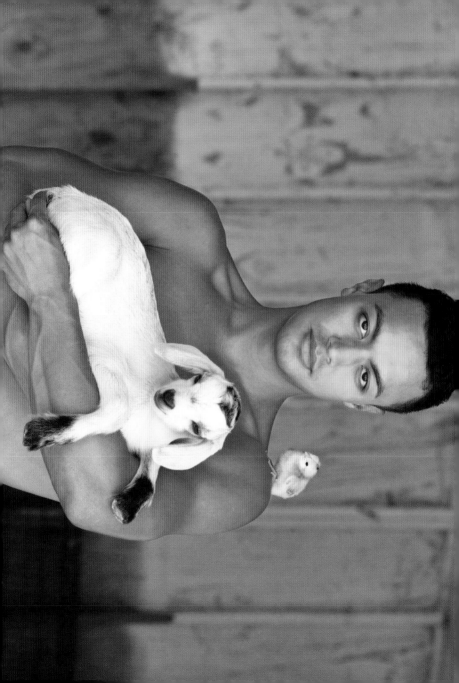

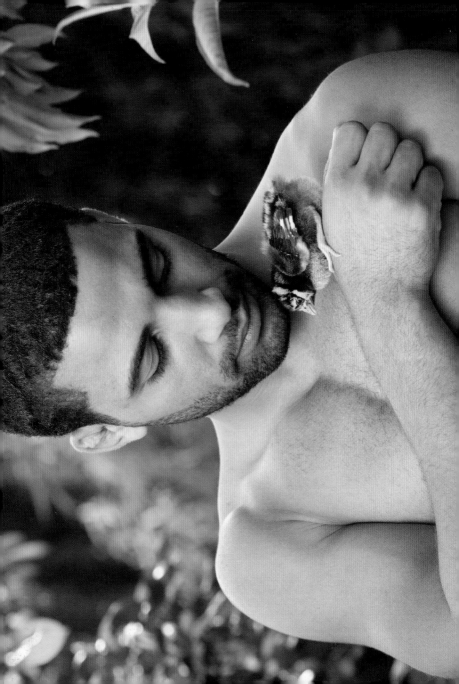

CHAD and SHEILA

Chad is the reason Sheila crossed the road.

Sheila is happy she got to the other side.

MARK and MILO

Mark is working to save a little nest egg.

Milo can barely scratch out a living.

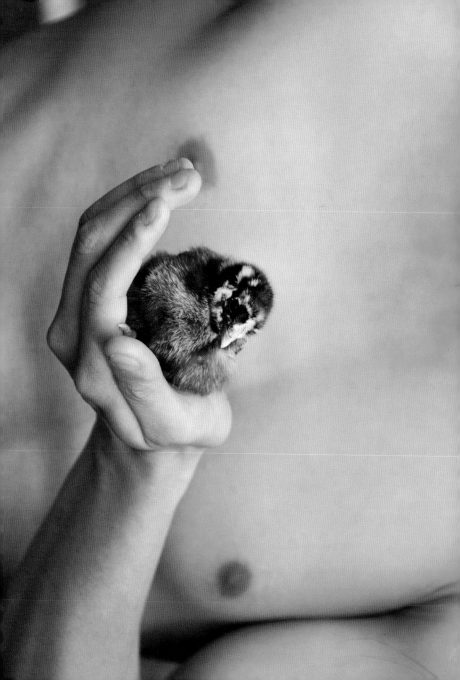

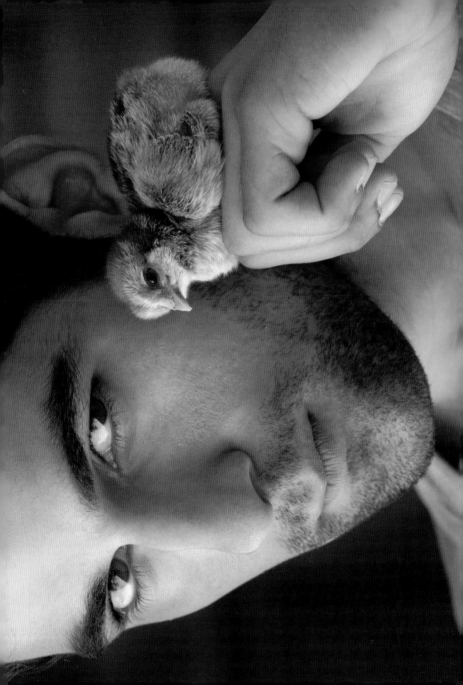

OUZI and OTHELLO

Ouzi is Turkish.

Othello is peckish.

BRENDAN *and* LULU

Brendan is a personal trainer.

Lulu prefers her guys with sharp beaks and skinny legs.

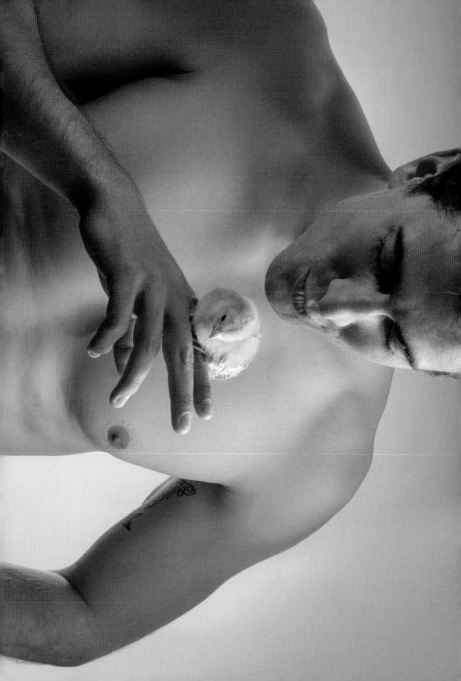

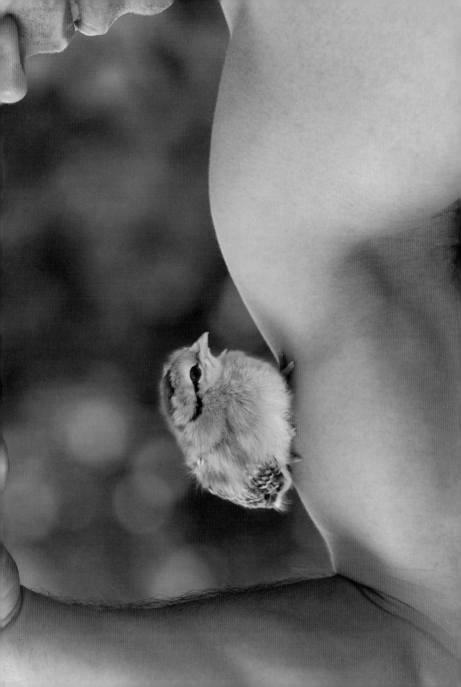

CLARK and CLARA

Clark works out.

Clara is impressed.

NATE and JENNIFER

Nate is open about his feelings.

Jennifer isn't looking for a commitment right now.

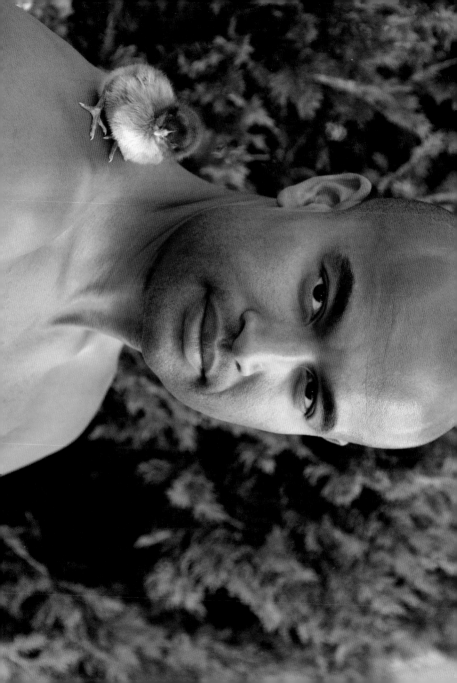

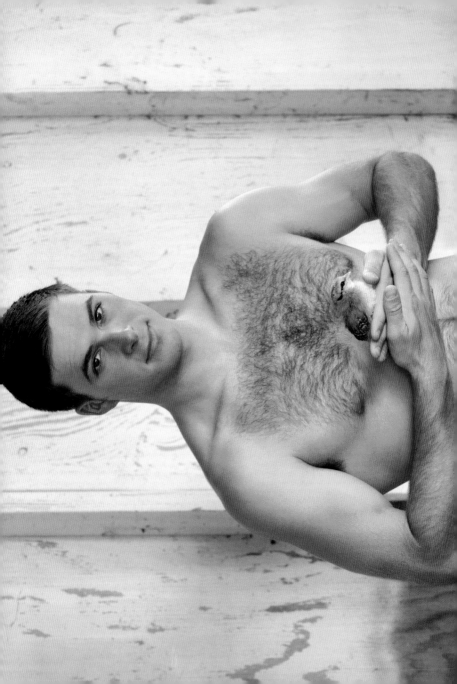

DYLAN and DELILAH

Dylan is willing to go to chick flicks.

Delilah only watches slasher films.

LAKU and LARRY

Laku is the strong, silent type.

Larry is the soft, fuzzy, talkative type.

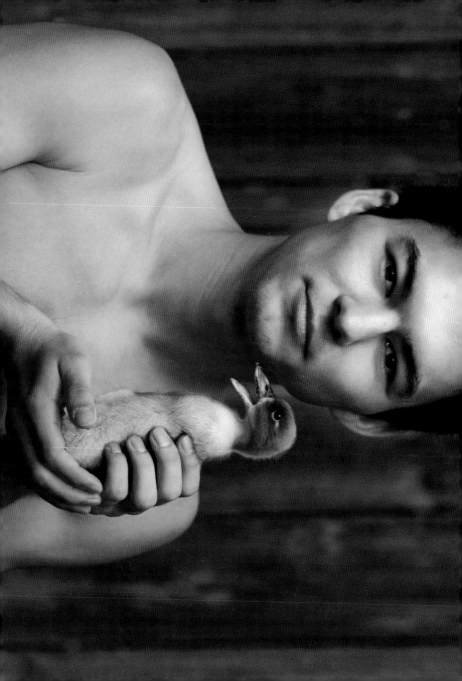

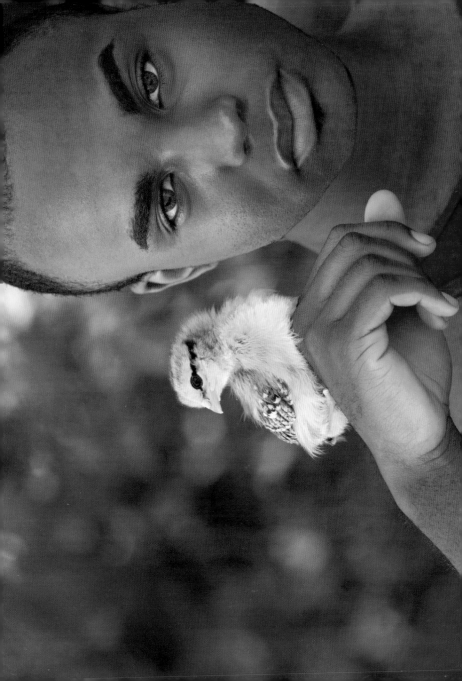

THOMAS and TALULAH

Thomas likes to wear eyeliner to make his eyes pop.

Talulah also likes to wear eyeliner.

DYLAN *and* SAVANNAH

Dylan takes the bus to work.

Savannah prefers to travel by hat.

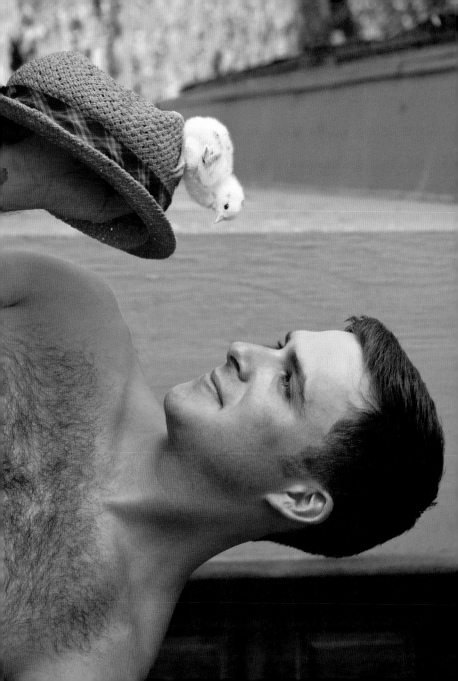

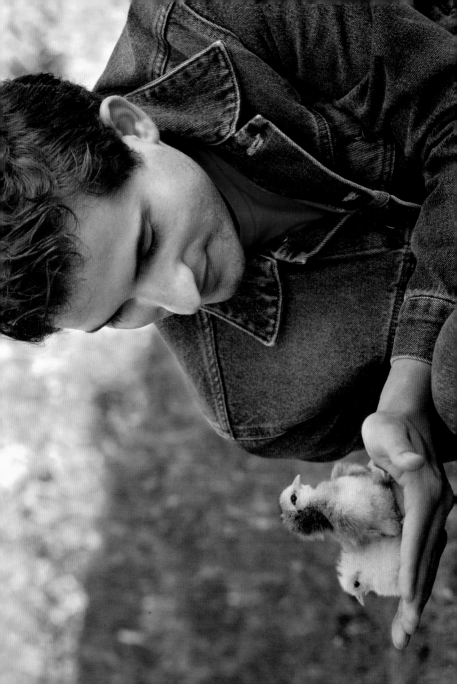

YANIG, BUTTON, and BOWS

Yanig speaks three languages—English, French, and Spanish.

Button and Bows think talk is *cheep*.

DANIEL and JASMINE

Daniel takes a subtle approach to seduction.

Jasmine's tail shake brings all the boys to the yard.

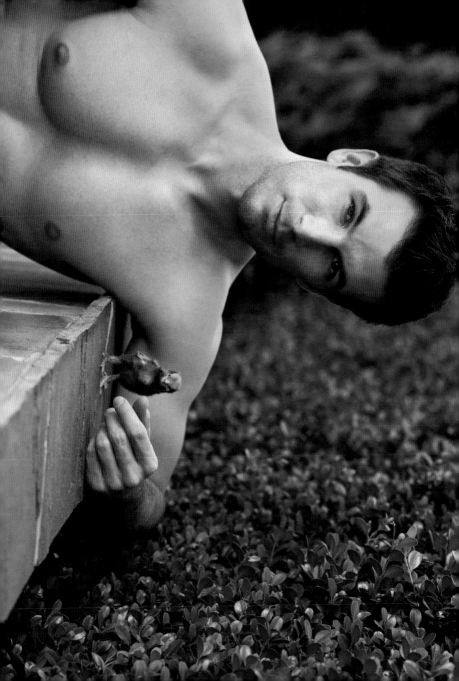

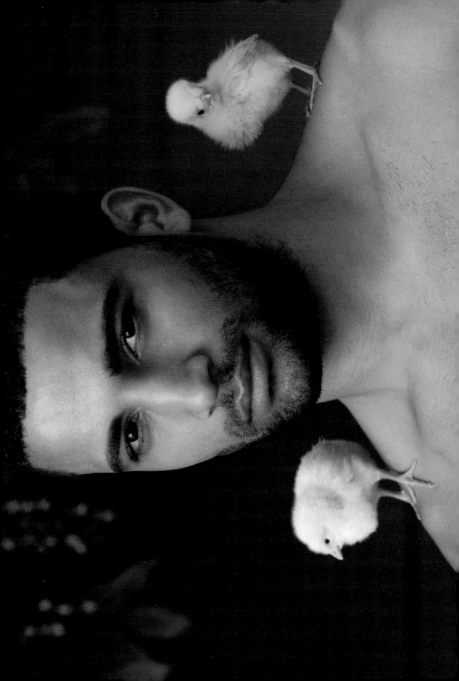

CHAD, DAVE, and CHESTER

Chad wants to learn more about you.

Dave and Chester are extremely disappointed in you.

MARK and BROOKLYN

Mark is being stalked by a jealous rooster.

Brooklyn feels safe in Mark's hands.

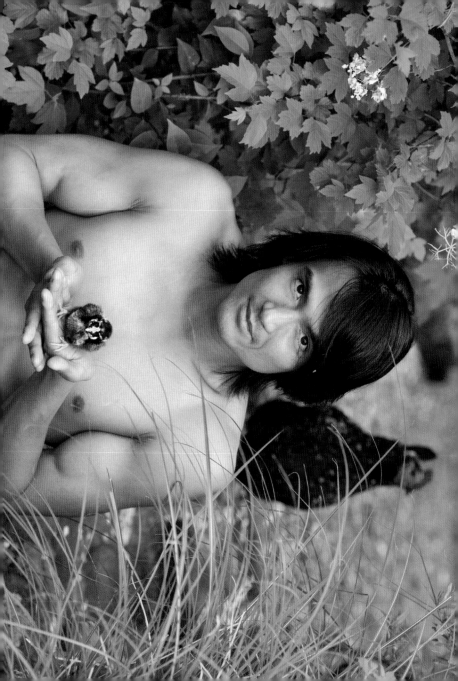

CHRISTOPHER and PIPER

Christopher sings the melody.

Piper sings the harmony.

RYAN *and* GEORGE

Ryan likes to surf the waves.

George likes to surf Ryan's shoulder.

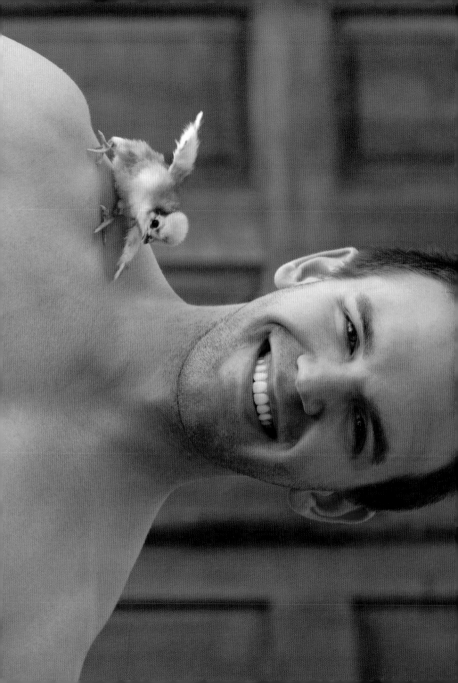

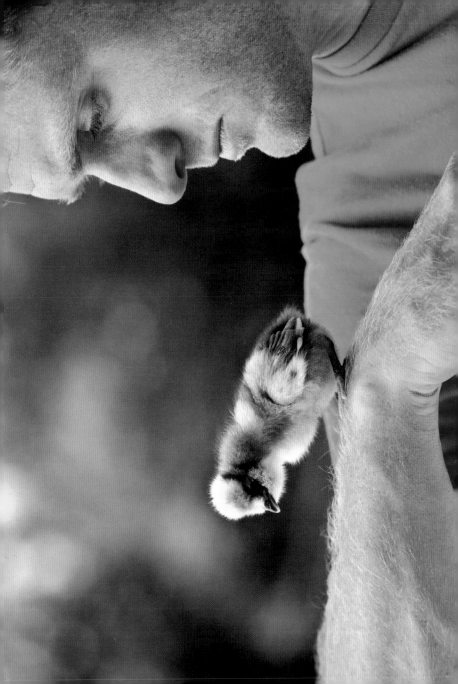

SOLOMON and CARLOS

Solomon is very grounded.

Carlos longs to fly the coop.

BRANDON and LEONARD

Brandon is thinking about how small and adorable Leonard is.

Leonard is also thinking about how small and adorable he is.

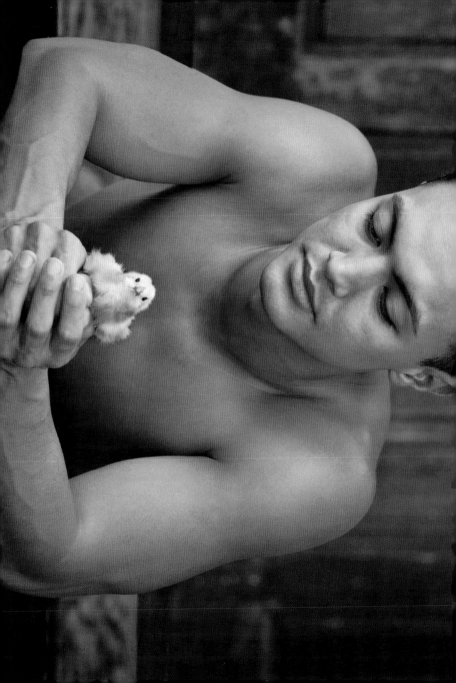

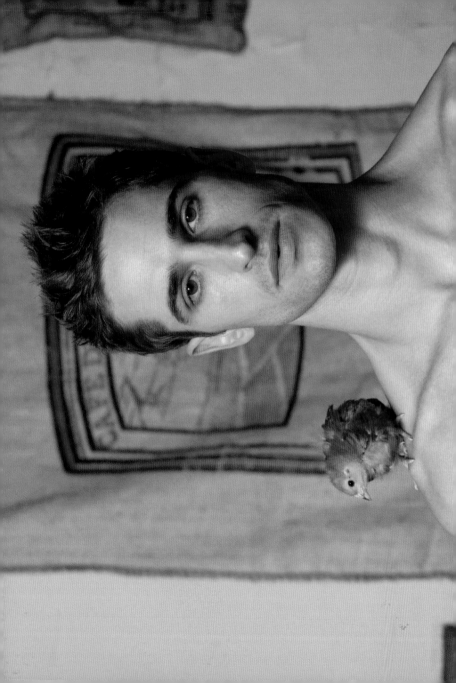

ANDREW and POPEYE

Andrew has been to twenty-six different countries.

Popeye is afraid of flying.

LAKU and KIM

Laku is half Japanese and half Italian.

Kim is distantly related to Donald.

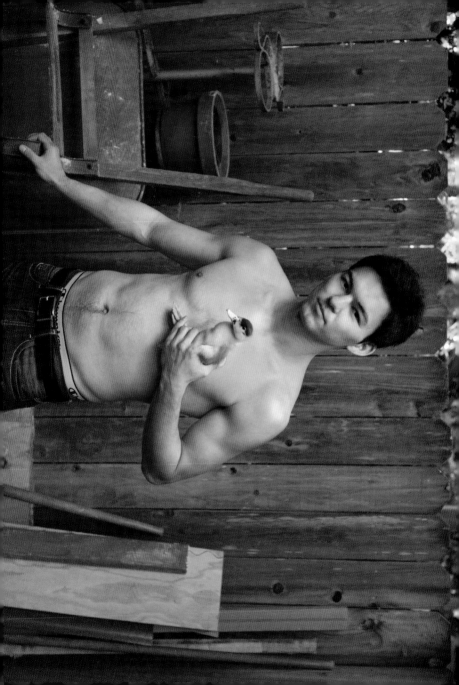

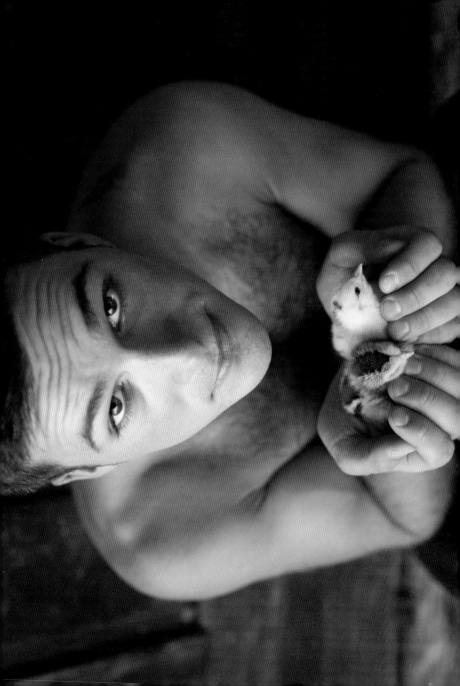

DYLAN, CHARLES, and MONICA

Dylan is single and looking to mingle.

Charles and Monica are hoping he's into threesomes.

CHAD and ZELDA

Chad is man enough to pose with a chick.

Zelda knows she can hold her own with any hot guy.

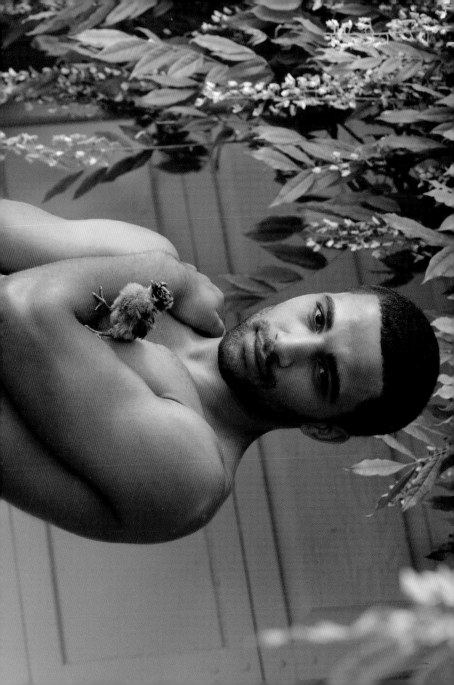

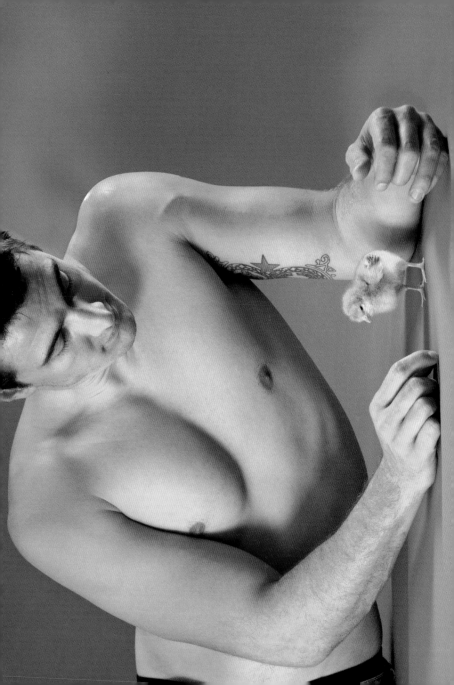

BRENDAN and MR. PEEPS

Brendan is too shy to dance in public.

Mr. Peeps likes to shake a tail feather.

OUZI and MARCUS

Ouzi works at a photography shop.

The camera loves Marcus.

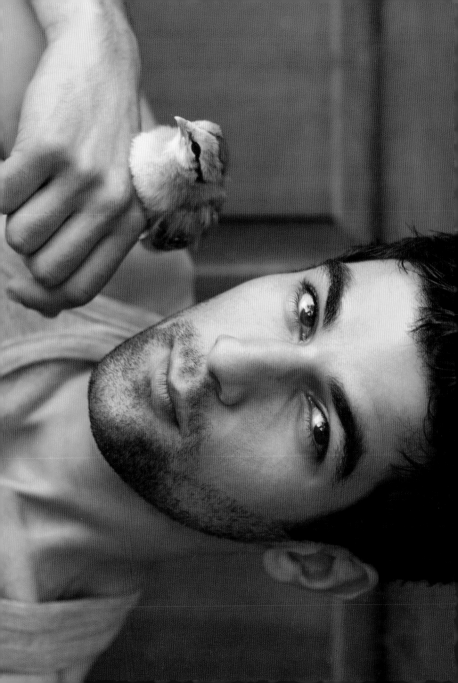

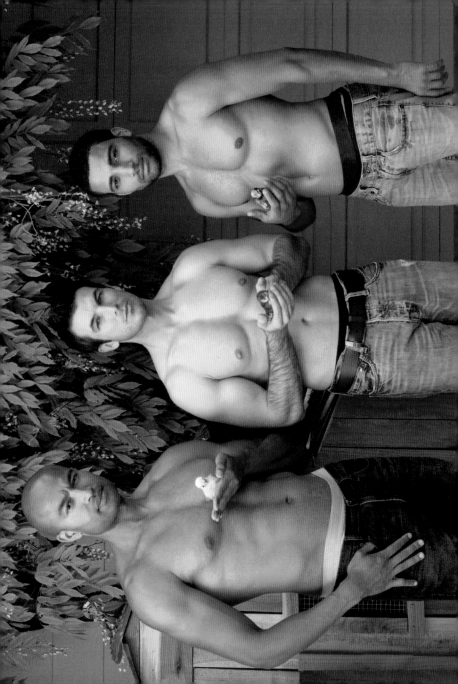

NATE, DANIEL, and CHAD

These guys are great at picking up chicks.

These chicks are looking for something a little more serious.